Try Your Colors

Black /1\ /△\ /△\ /12\ Yellow Green
Gray /2\ /△\ /△\ /13\ Green
Dark Brown /3\ /△\ /△\ /14\ Dark Green
Brown /4\ /△\ /△\ /15\ Aqua Green
Tan /5\ /△\ /△\ /16\ Light Blue
Peach /6\ /△\ /△\ /17\ Blue
Red /7\ /△\ /△\ /18\ Dark Blue
Red Orange /8\ /△\ /△\ /19\ Pink
Orange /9\ /△\ /△\ /20\ Violet
Yellow Orange /10\ /△\ /△\ /21\ Dark Violet
Yellow /11\ /△\ /△\ /22\ Magenta

◁ 12 Yellow Green
◁ 13 Green
◁ 14 Dark Green
◁ 15 Aqua Green
◁ 16 Light Blue
◁ 19 Pink
◁ 20 Violet
◁ 21 Dark Violet
◁ 22 Magenta

Black ◁ 1
◁ 3 Dark Brown
◁ 4 Brown
◁ 6 Peach
◁ 7 Red
◁ 8 Red Orange
◁ 9 Orange
◁ 10 Yellow Orange
◁ 11 Yellow

	
3	Dark Brown
4	Brown
5	Tan
6	Peach
7	Red
9	Orange
10	Yellow Orange
11	Yellow
12	Yellow Green
13	Green
14	Dark Green
16	Light Blue
17	Blue
18	Dark Blue
19	Pink
20	Violet
21	Dark Violet
22	Magenta

Dark Brown △3 △12 Yellow Green
△13 Green
△14 Dark Green

△16 Light Blue
△17 Blue
Red △7

△19 Pink
△20 Violet
Yellow Orange △10 △21 Dark Violet
Yellow △11 △22 Magenta

#	Color	#	Color
1	Black	12	Yellow Green
2	Gray	13	Green
3	Dark Brown	14	Dark Green
4	Brown	15	Aqua Green
5	Tan	16	Light Blue
6	Peach	17	Blue
8	Red Orange	18	Dark Blue
9	Orange	19	Pink
		20	Violet
		22	Magenta

△12 Yellow Green
△13 Green

Dark Brown △3
Brown △4
Tan △5
Peach △6 △17 Blue
Red △7 △18 Dark Blue
Red Orange △8 △19 Pink
Orange △9 △20 Violet
Yellow Orange △10 △21 Dark Violet
Yellow △11 △22 Magenta

△1 Black	△12 Yellow Green
△3 Dark Brown	△13 Green
△4 Brown	△15 Aqua Green
△5 Tan	△16 Light Blue
△6 Peach	△19 Pink
△8 Red Orange	△20 Violet
△10 Yellow Orange	△21 Dark Violet
△11 Yellow	

		△12	Yellow Green
		△13	Green
Dark Brown	△3	△14	Dark Green
Brown	△4	△15	Aqua Green
		△17	Blue
		△18	Dark Blue
Red Orange	△8	△19	Pink
Orange	△9		
Yellow Orange	△10	△21	Dark Violet
Yellow	△11	△22	Magenta

⚠ 12 Yellow Green
⚠ 13 Green
⚠ 14 Dark Green
⚠ 16 Light Blue
⚠ 17 Blue
⚠ 18 Dark Blue
⚠ 20 Violet
⚠ 21 Dark Violet
⚠ 22 Magenta
Orange ⚠ 9
Yellow Orange ⚠ 10
Yellow ⚠ 11

Black △1 △12 Yellow Green
Gray △2 △13 Green
Dark Brown △3 △14 Dark Green

△17 Blue

Red Orange △8 △19 Pink
Orange △9 △20 Violet
Yellow Orange △10
Yellow △11 △22 Magenta

△ 12 Yellow Green
△ 13 Green
△ 14 Dark Green
△ 16 Light Blue
△ 17 Blue
△ 18 Dark Blue
Tan △ 5
Peach △ 6
Yellow △ 11

Black △1 △12 Yellow Green
　　　　　　△13 Green
Dark Brown △3 △14 Dark Green
Brown △4
Tan △5 △16 Light Blue
Peach △6 △17 Blue
　　　　　　△18 Dark Blue
　　　　　　△19 Pink
　　　　　　△20 Violet
　　　　　　△21 Dark Violet
　　　　　　△22 Magenta

△ 3 Dark Brown
△ 5 Tan
△ 6 Peach
△ 8 Red Orange
△ 9 Orange
△ 10 Yellow Orange
△ 11 Yellow
△ 12 Yellow Green
△ 13 Green
△ 14 Dark Green
△ 17 Blue
△ 18 Dark Blue
△ 20 Violet
△ 21 Dark Violet

	△12 Yellow Green
	△13 Green
Dark Brown △3	△14 Dark Green
	△15 Aqua Green
Tan △5	△16 Light Blue
Peach △6	△17 Blue
Red △7	△18 Dark Blue
Red Orange △8	△19 Pink
Orange △9	
Yellow Orange △10	
Yellow △11	△22 Magenta

△ 7 Red △ 9 Orange △ 10 Yellow Orange △ 11 Yellow △ 19 Pink △ 20 Violet △ 21 Dark Violet

Black △1 △12 Yellow Green
 △13 Green

 △15 Aqua Green
 △16 Light Blue
 △17 Blue
Red △7 △18 Dark Blue
Red Orange △8 △19 Pink
Orange △9 △20 Violet
Yellow Orange △10 △21 Dark Violet
Yellow △11 △22 Magenta

- △3 Dark Brown
- △4 Brown
- △7 Red
- △8 Red Orange
- △9 Orange
- △10 Yellow Orange
- △11 Yellow
- △12 Yellow Green
- △13 Green
- △14 Dark Green
- △15 Aqua Green
- △16 Light Blue
- △17 Blue
- △18 Dark Blue
- △19 Pink
- △22 Magenta

Black △1　△12 Yellow Green
△13 Green
△14 Dark Green
△15 Aqua Green
△16 Light Blue
△17 Blue
Red △7　△18 Dark Blue
Red Orange △8
Orange △9　△20 Violet
Yellow Orange △10　△21 Dark Violet
Yellow △11　△22 Magenta

	
3	Dark Brown
4	Brown
5	Tan
6	Peach
7	Red
8	Red Orange
9	Orange
10	Yellow Orange
11	Yellow
12	Yellow Green
13	Green
14	Dark Green
16	Light Blue
18	Dark Blue
19	Pink
20	Violet
21	Dark Violet
22	Magenta

Black △1 △12 Yellow Green
Gray △2 △13 Green
Dark Brown △3 △14 Dark Green

Tan △5
Peach △6
Red △7
Red Orange △8 △19 Pink
Orange △9 △20 Violet
Yellow Orange △10
Yellow △11 △22 Magenta

△ 12 Yellow Green
△ 13 Green
△ 14 Dark Green
△ 15 Aqua Green
△ 16 Light Blue
△ 17 Blue
△ 18 Dark Blue
△ 19 Pink
△ 20 Violet
△ 21 Dark Violet

Dark Brown △ 3
Brown △ 4
Tan △ 5
Peach △ 6
Red △ 7
Red Orange △ 8
Yellow Orange △ 10
Yellow △ 11

Black △1 △12 Yellow Green
　　　　　　△13 Green
Dark Brown △3 △14 Dark Green
Brown △4 △15 Aqua Green
Tan △5 △16 Light Blue
Peach △6 △17 Blue
　　　　　　△18 Dark Blue

Orange △9
Yellow Orange △10
Yellow △11

△12 Yellow Green
△13 Green
△14 Dark Green
△15 Aqua Green
△16 Light Blue
△17 Blue

Red △7
Red Orange △8
Orange △9

Yellow △11

Black △1 △12 Yellow Green
 △13 Green
 △14 Dark Green
 △15 Aqua Green

Red △7
Red Orange △8
Orange △9
Yellow Orange △10
Yellow △11

△3 Dark Brown
△4 Brown
△5 Tan
△6 Peach
△10 Yellow Orange
△11 Yellow
△12 Yellow Green
△13 Green
△14 Dark Green
△16 Light Blue
△18 Dark Blue
△19 Pink
△21 Dark Violet
△22 Magenta

△ 3 Dark Brown
△ 4 Brown
△ 5 Tan
△ 6 Peach
△ 7 Red
△ 8 Red Orange
△ 10 Yellow Orange
△ 12 Yellow Green
△ 13 Green
△ 14 Dark Green
△ 15 Aqua Green
△ 16 Light Blue
△ 17 Blue
△ 18 Dark Blue
△ 19 Pink
△ 20 Violet
△ 21 Dark Violet

	△12 Yellow Green
	△13 Green
Dark Brown △3	△14 Dark Green
Brown △4	
Tan △5	
Peach △6	
Red Orange △8	△19 Pink
Orange △9	
Yellow Orange △10	
Yellow △11	△22 Magenta

	△12 Yellow Green
	△13 Green
Dark Brown △3	△14 Dark Green
Brown △4	
	△16 Light Blue
Peach △6	△17 Blue
Red △7	
Red Orange △8	△19 Pink
Orange △9	△20 Violet
Yellow Orange △10	△21 Dark Violet
Yellow △11	△22 Magenta

◁ 12 Yellow Green
◁ 13 Green
◁ 14 Dark Green

◁ 19 Pink
◁ 20 Violet
◁ 21 Dark Violet

◁ 1 Black
◁ 3 Dark Brown
◁ 4 Brown

◁ 8 Red Orange
◁ 9 Orange
◁ 10 Yellow Orange
◁ 11 Yellow

		12	Yellow Green
		13	Green
Dark Brown	3	14	Dark Green
Brown	4	15	Aqua Green
Tan	5	16	Light Blue
Peach	6	17	Blue
Red	7	18	Dark Blue
Red Orange	8	19	Pink
Orange	9		
Yellow Orange	10	21	Dark Violet
Yellow	11	22	Magenta

Printed in Great Britain
by Amazon

Enjoy 30 Color by Number pictures hidden by small triangles on various topics such as animals, travel, landscapes, flowers, people, birds.

Use the 22-color palette to create beautiful art-works!

Paperback books available on Amazon.com/author/ColorRelaxation

Printable PDF books available on Etsy.com/shop/ColorRelaxation

**All Rights Reserved
Copyright © Kira Shershneva, 2020
mail@KiraShershneva.ru**